Author

TATIANA
BOGEMA
(STOLOVA)

G000069173

Facebook: Tatiana Bogema (Stolova)

Hi! My name is Tatiana and I'm artist :)
I want to say thank you so much for choosing my books despite the large number of books present on the market. I really appreciate this. Every time I start new project I think about how to make my book mor interesting. And I can't do this without you. To do that I need to have your feedbacks. Communication with you is very very important for creation process. With your feedbacks you give me new ideas and inspiration for new books that become better and more interesting. Sincerely yors, Tatiana.

Nice Little Town 7 - Adult Coloring Book

Copyright © 2019 by Tatiana Bogema (Stolova)

ISBN: 9781794562066

All rights reserved. No portion of this book may be reproduced in any form without the written permission of the author. Colored pages of the illustration presented in this book may not be used in any commercial form.

THIS BOOK BELONGS TO

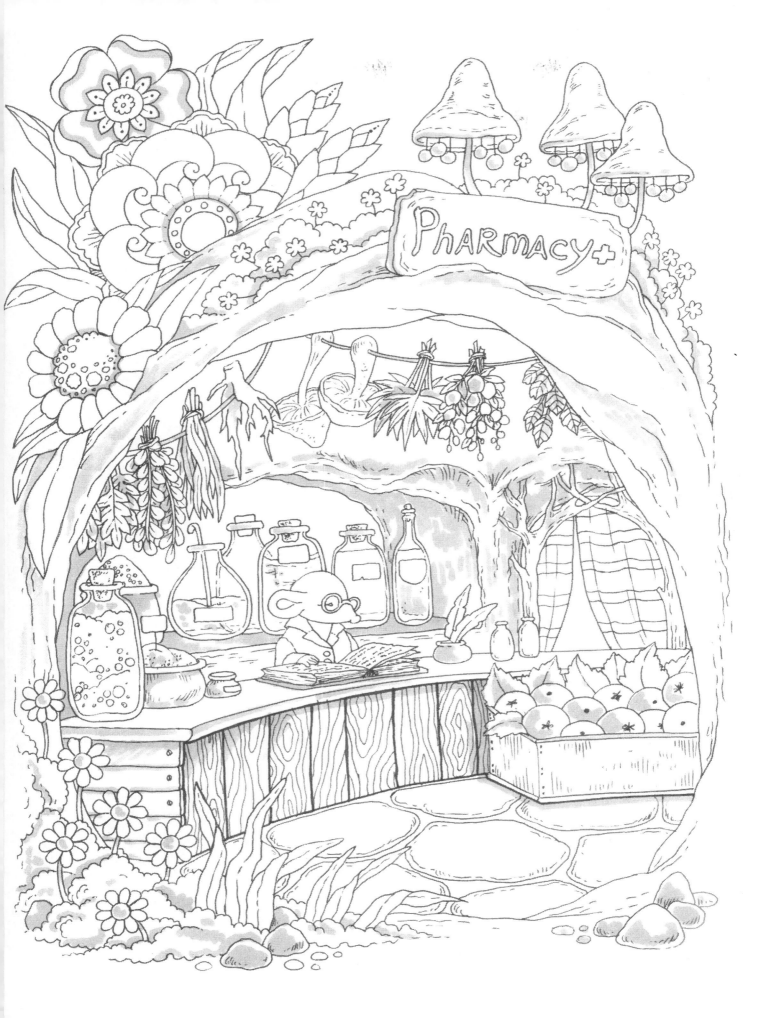

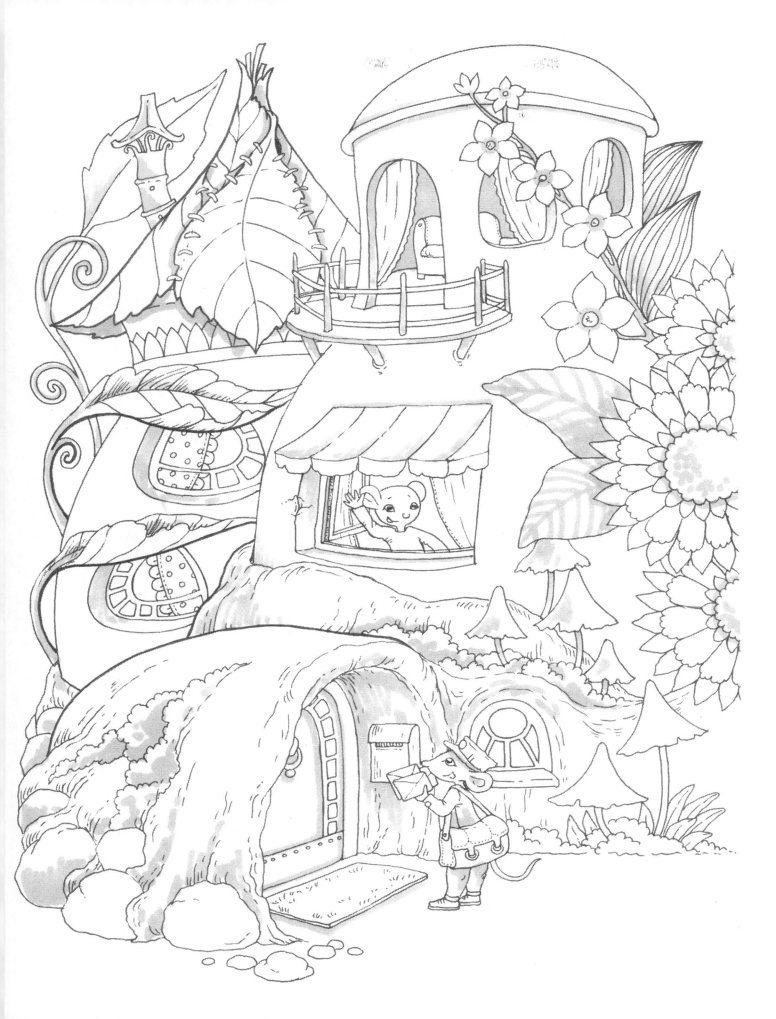

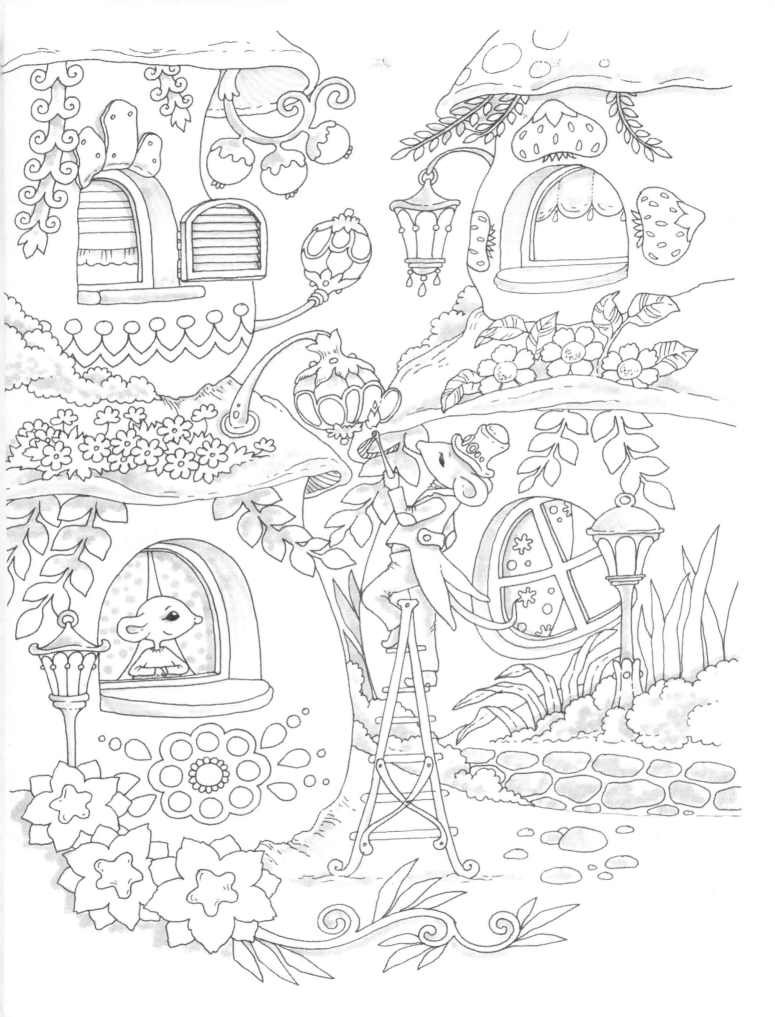

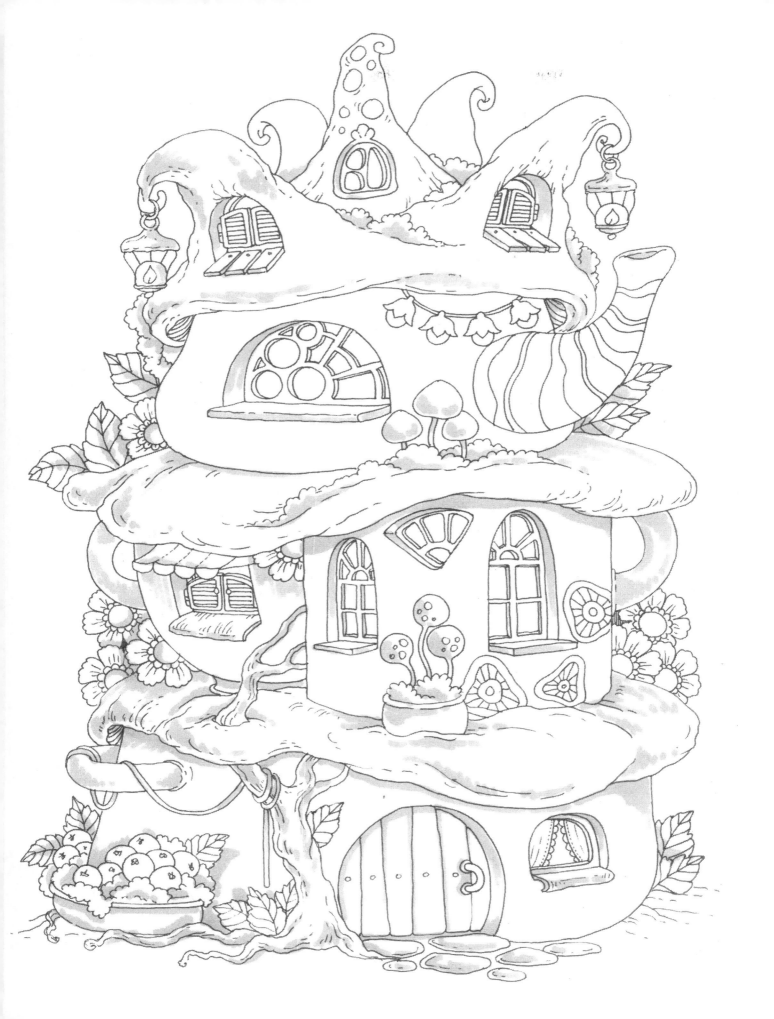

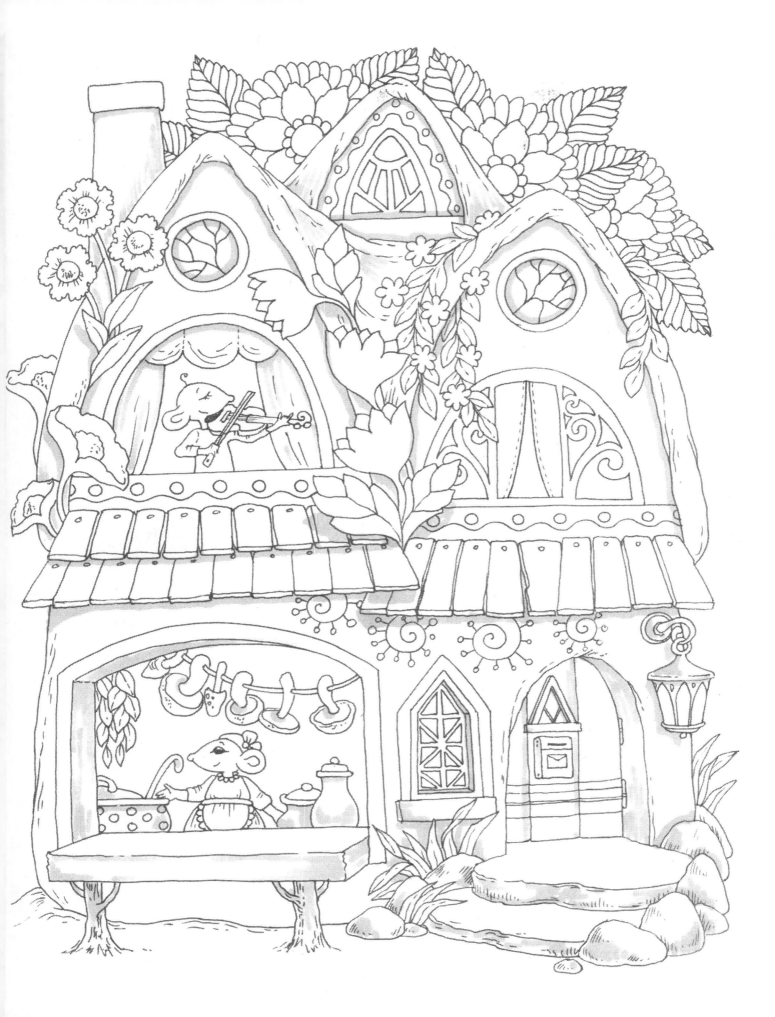

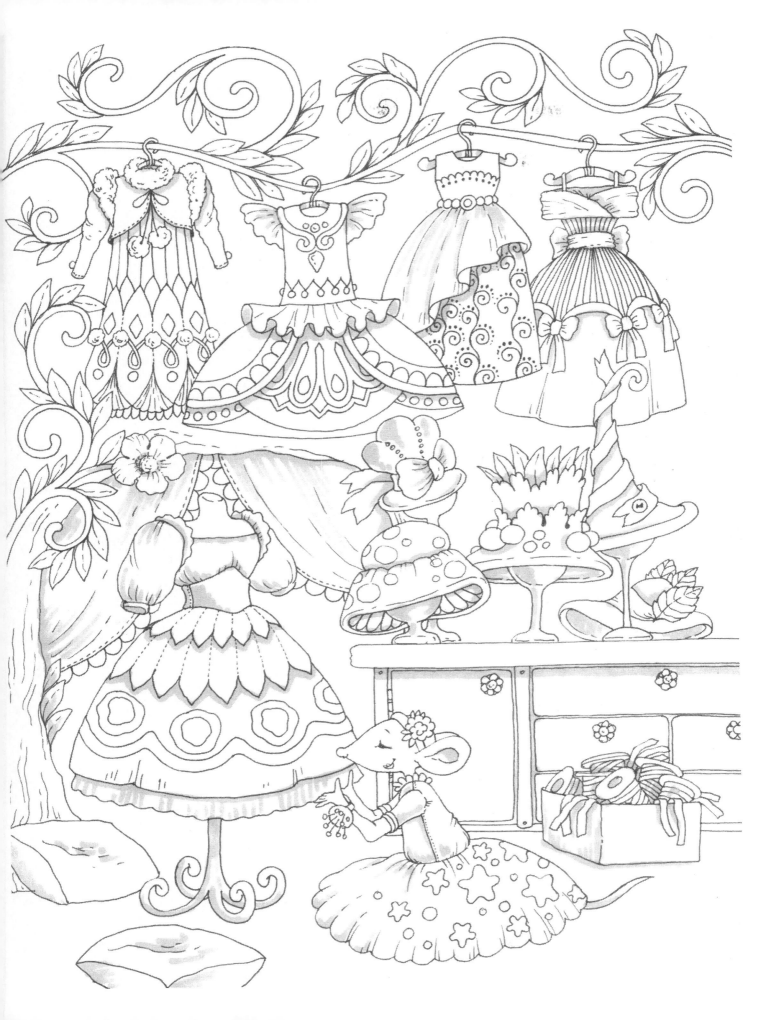

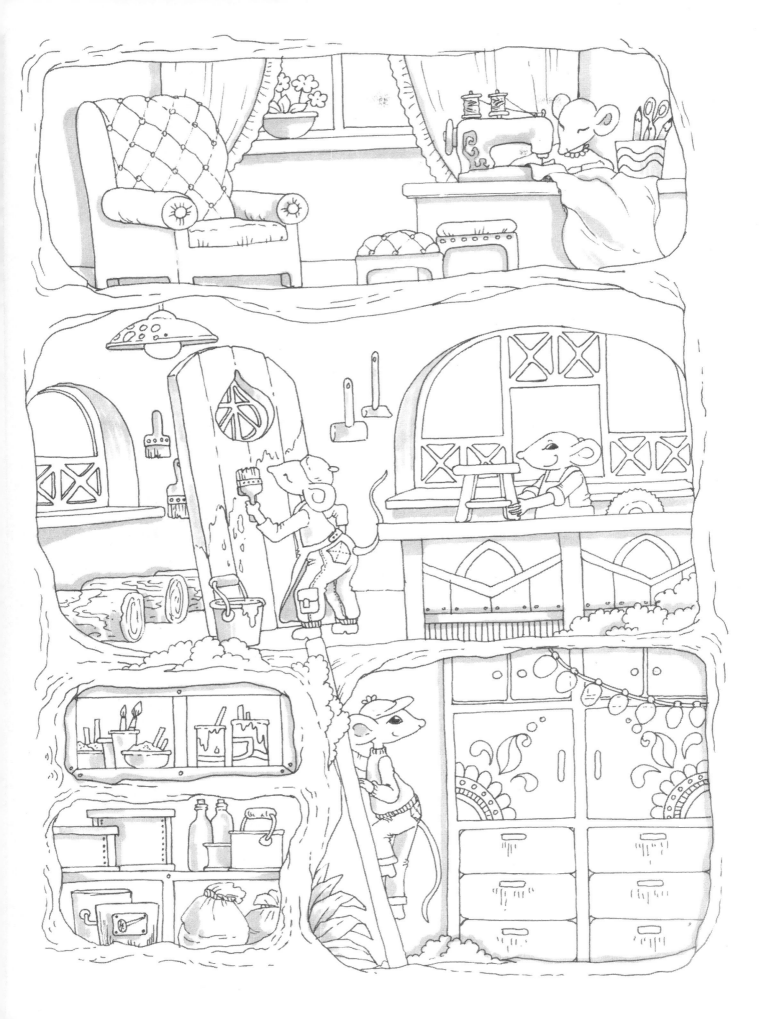

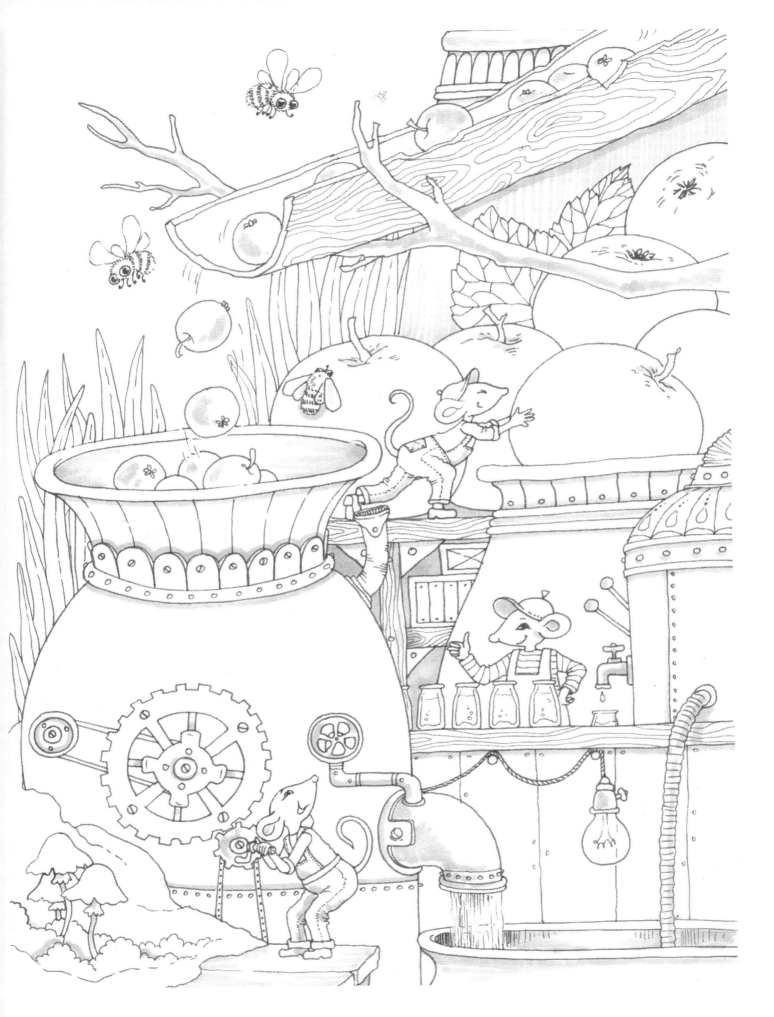

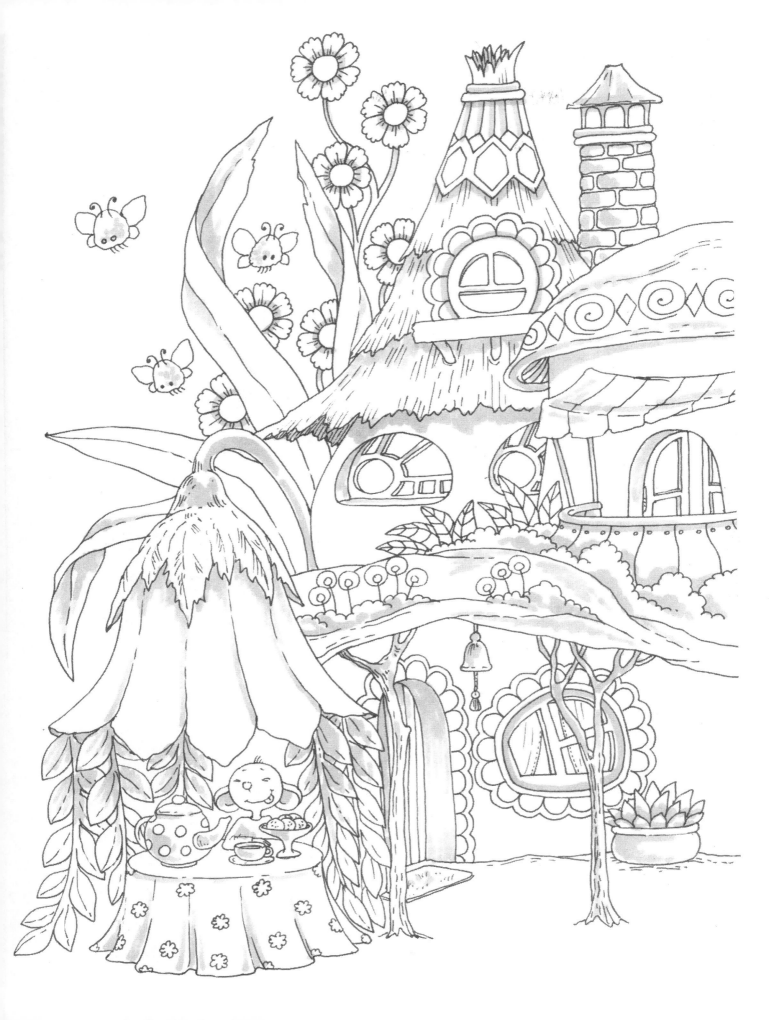

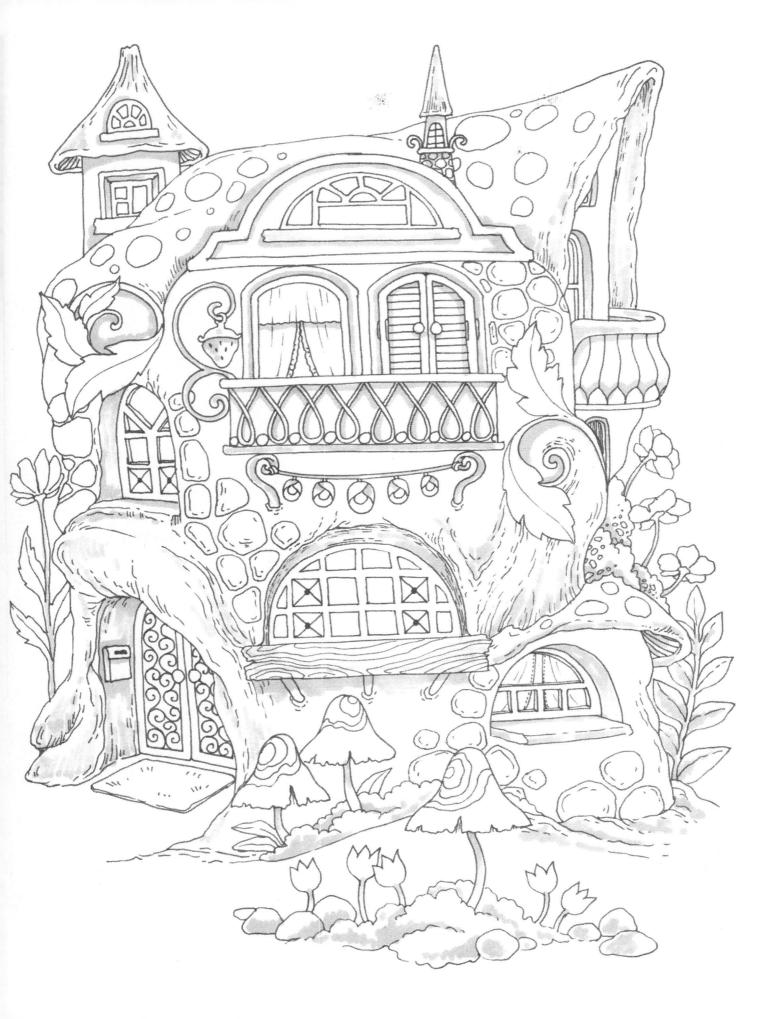

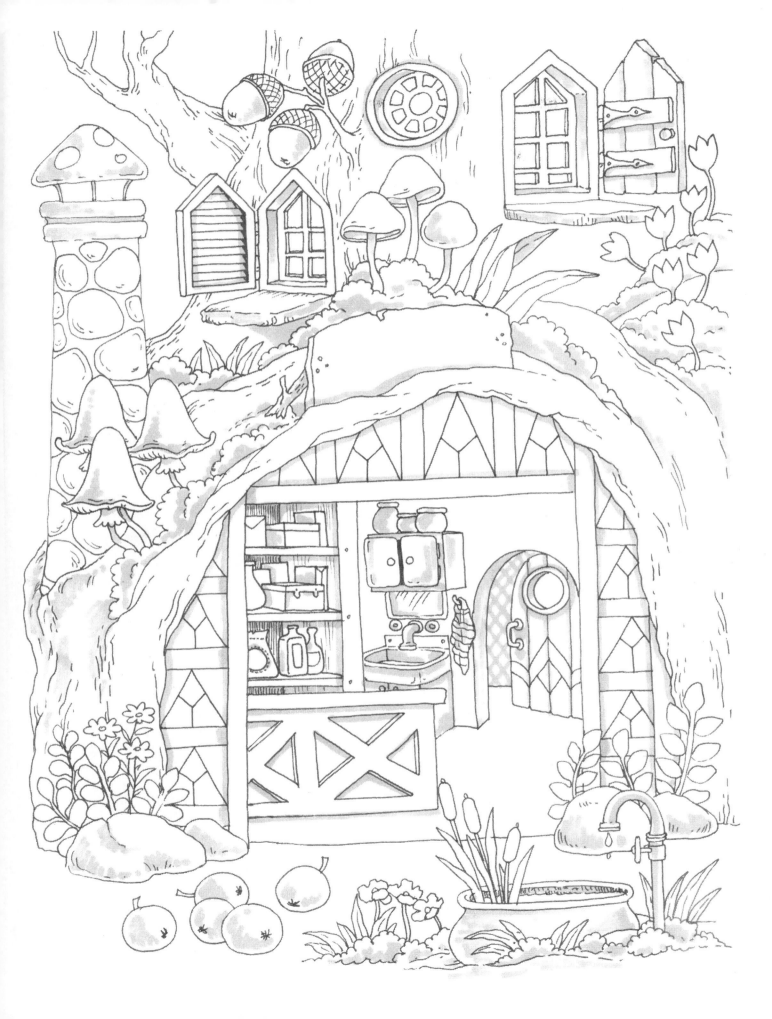

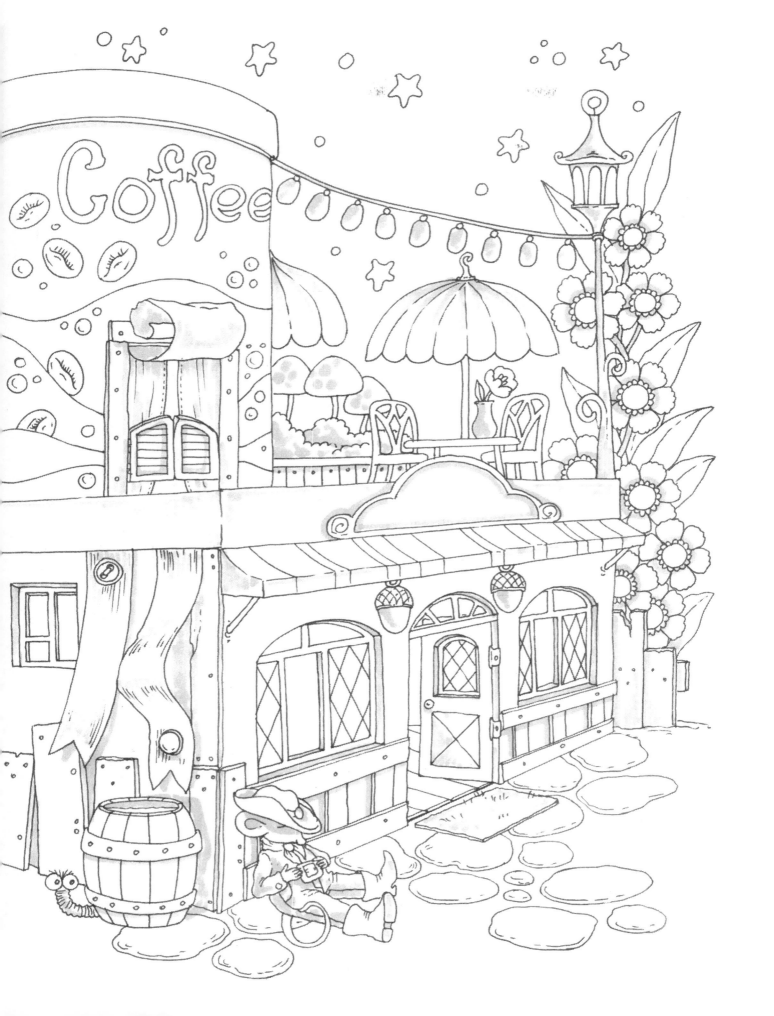

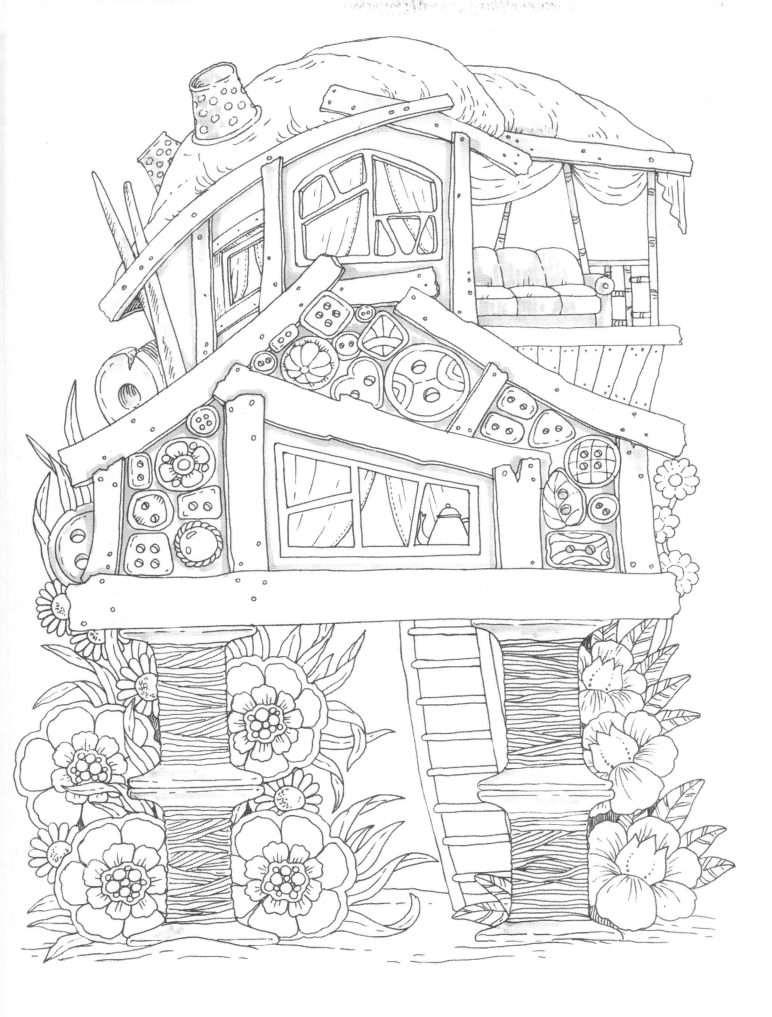

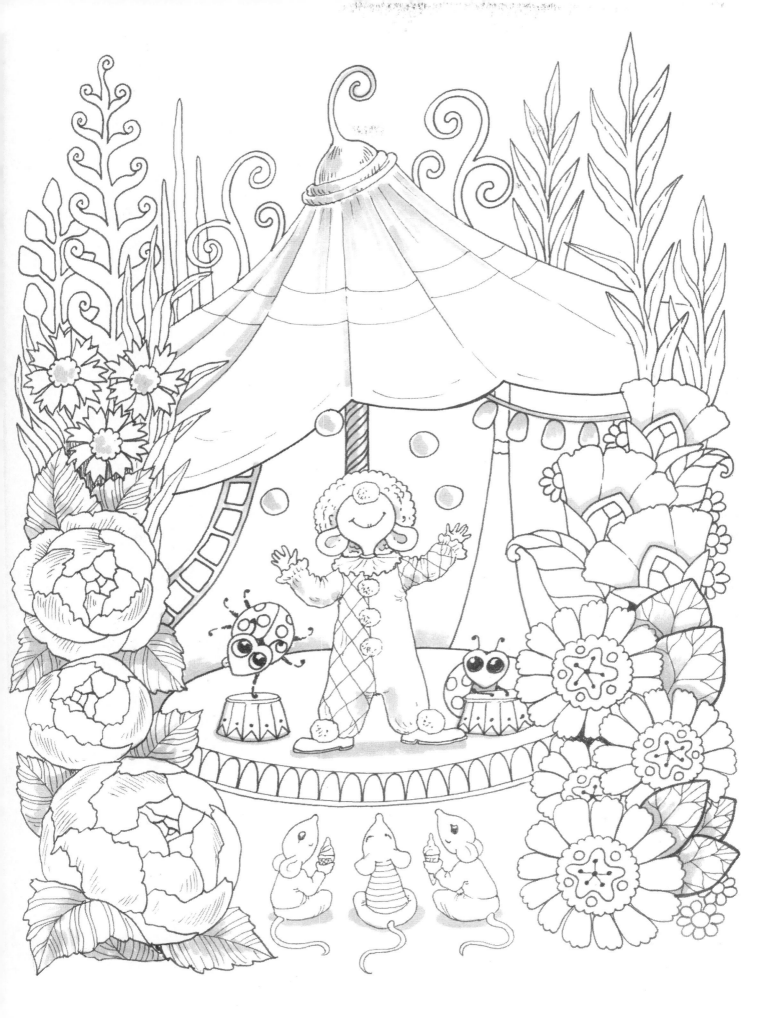

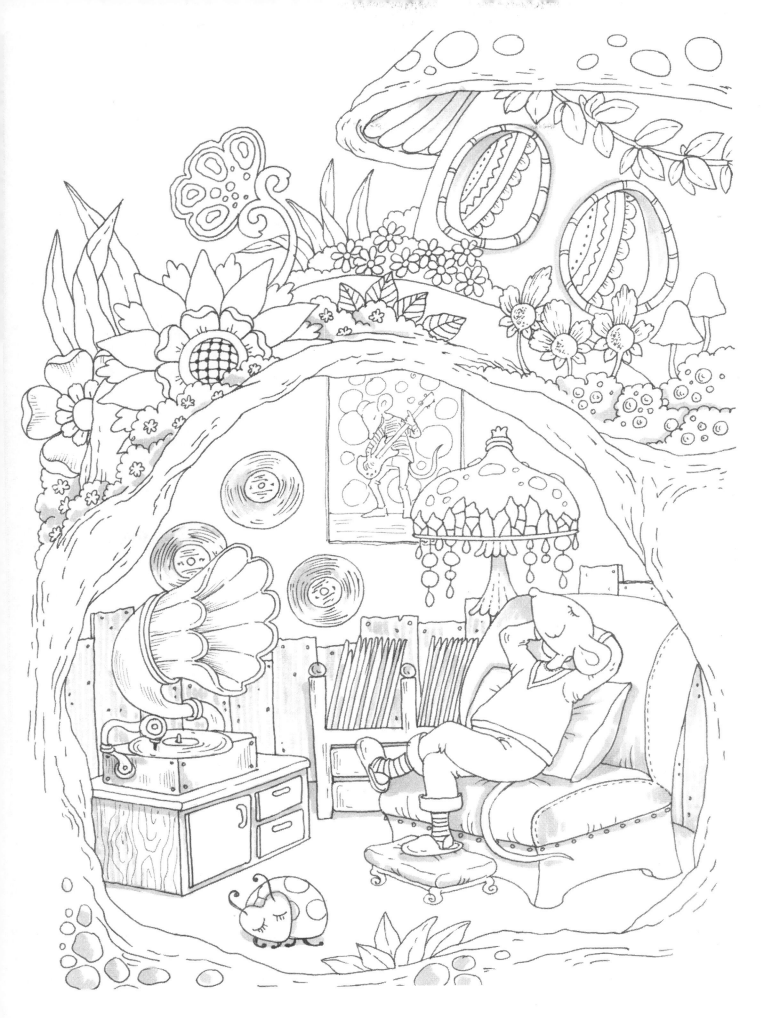

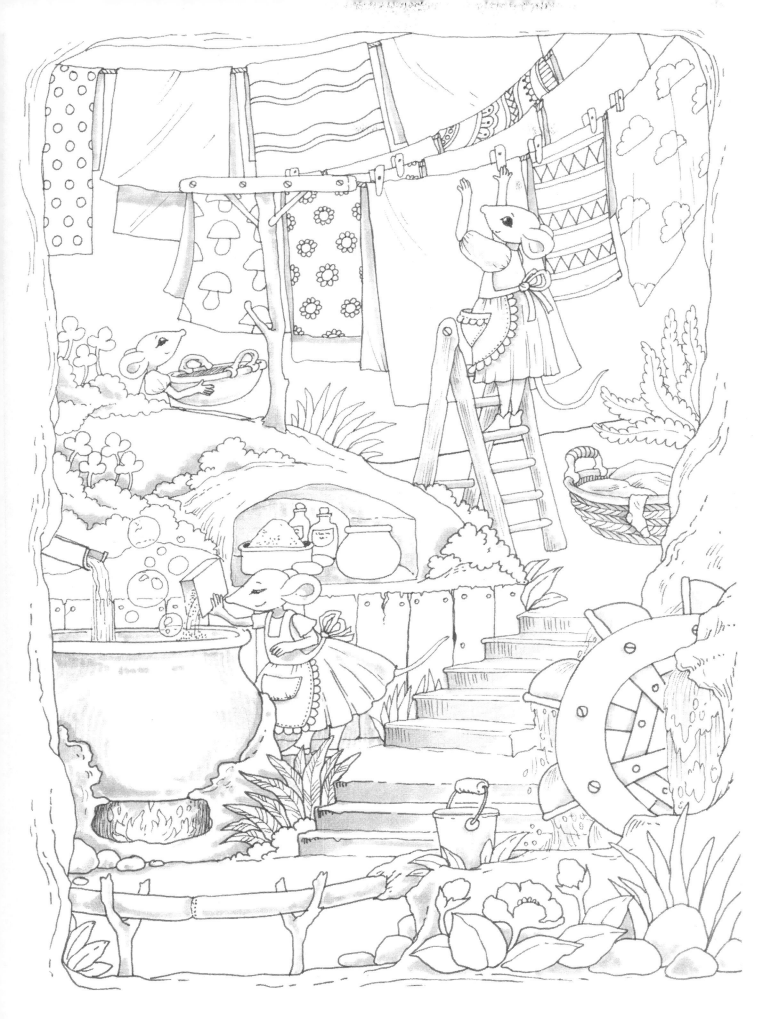

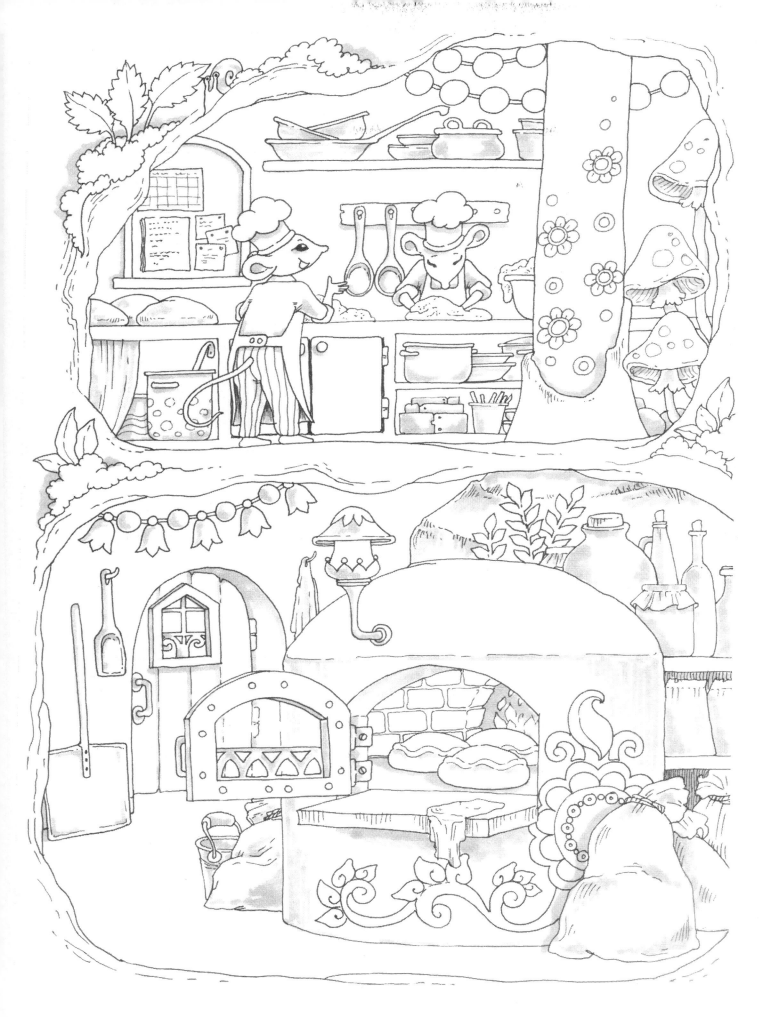

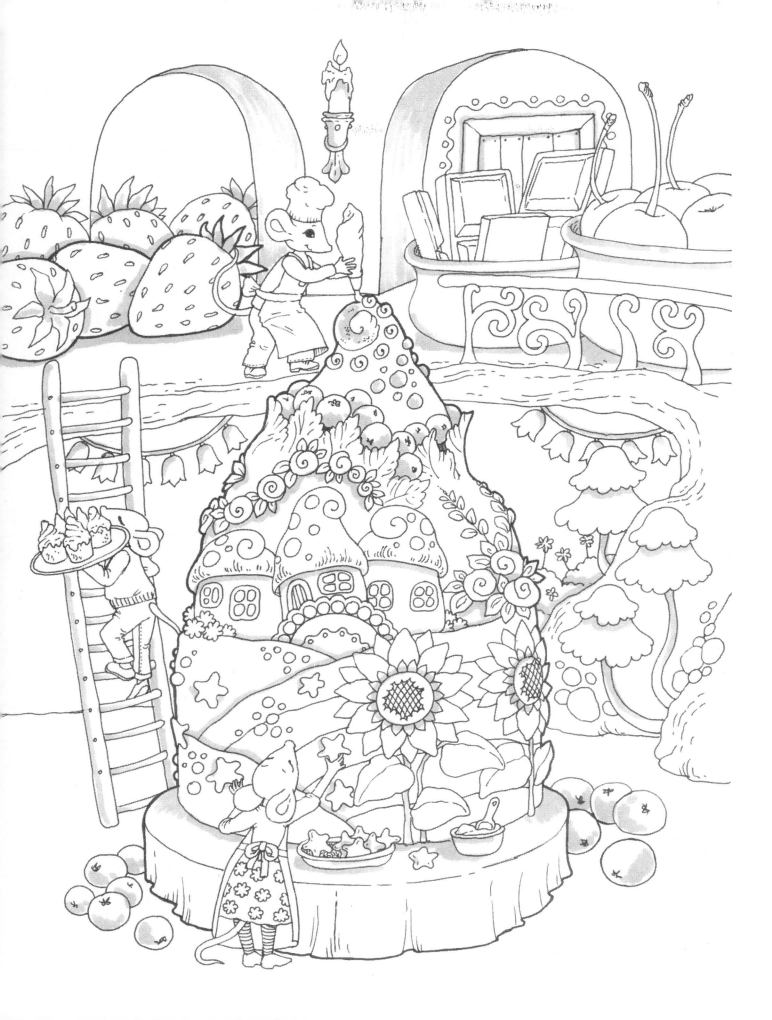

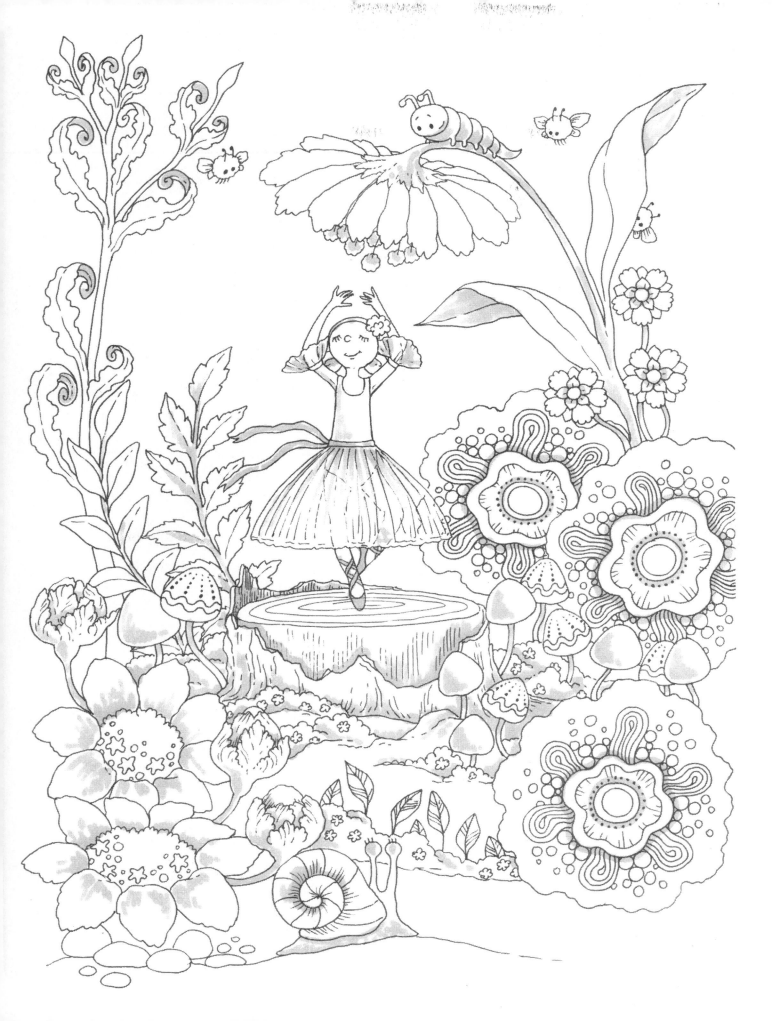

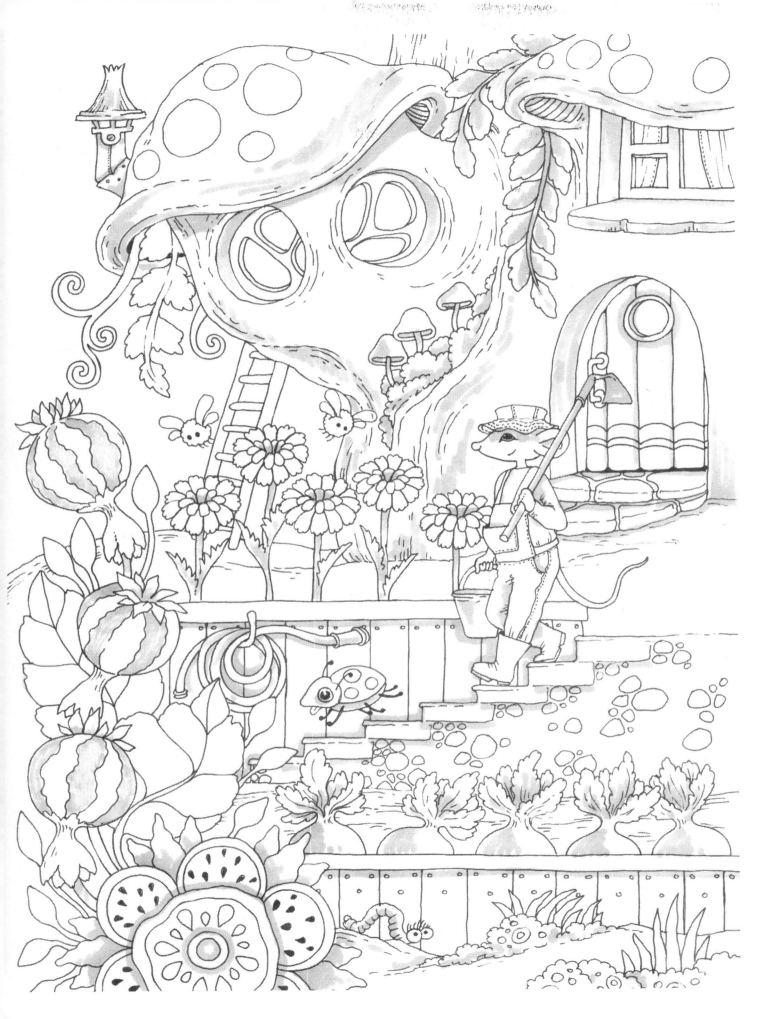

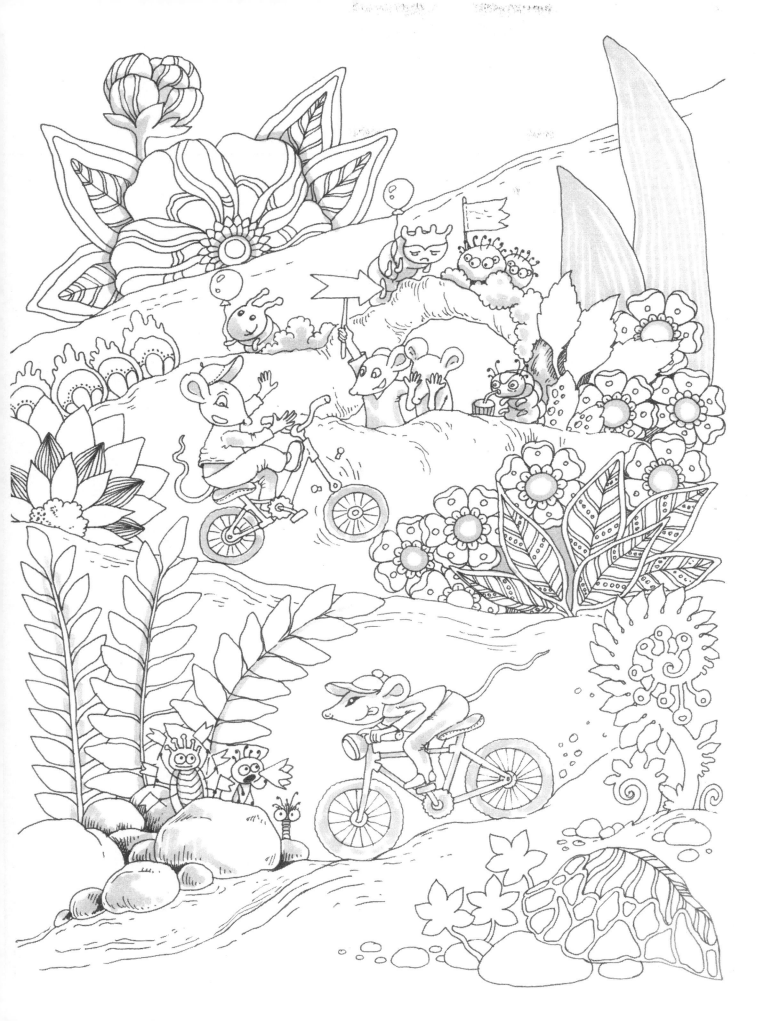

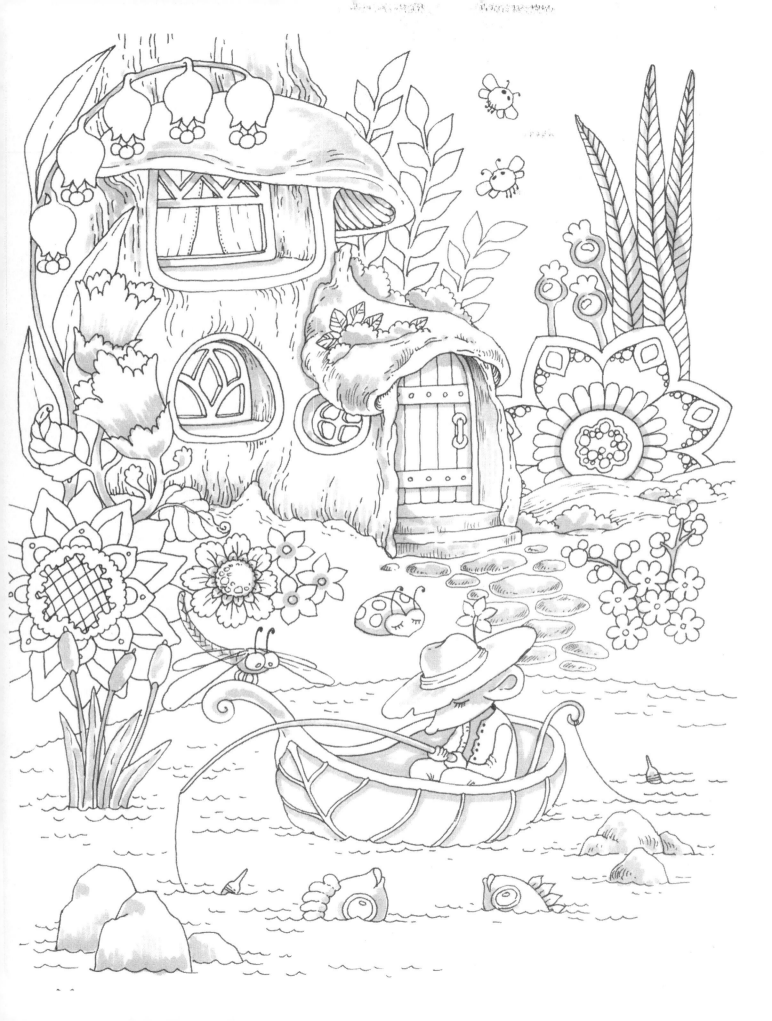

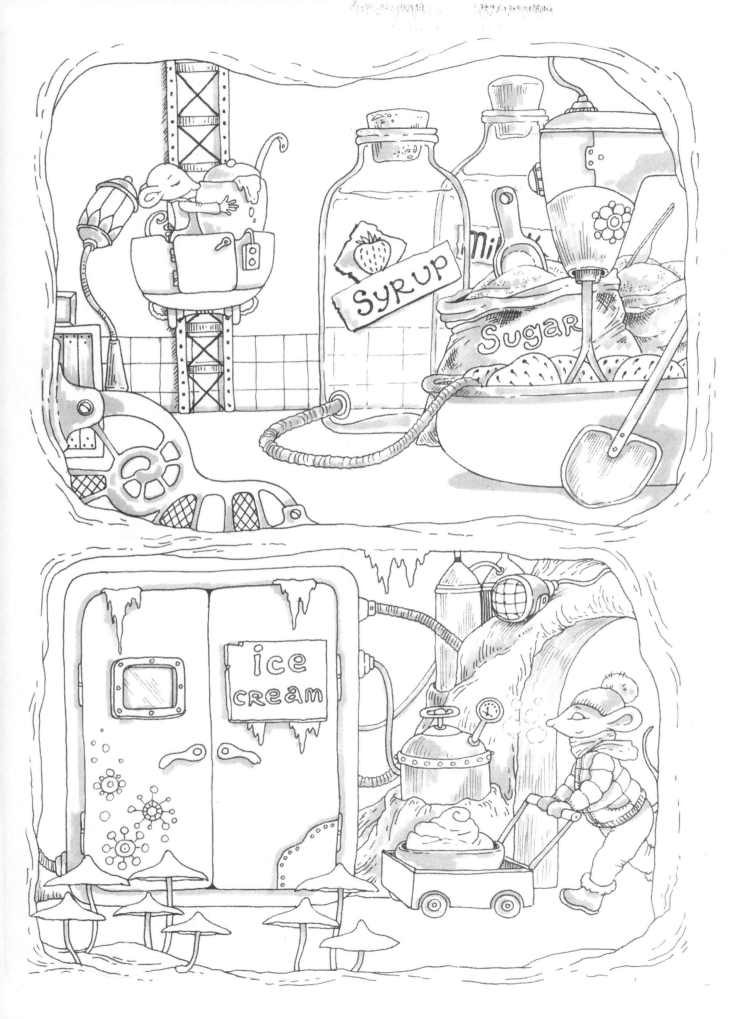

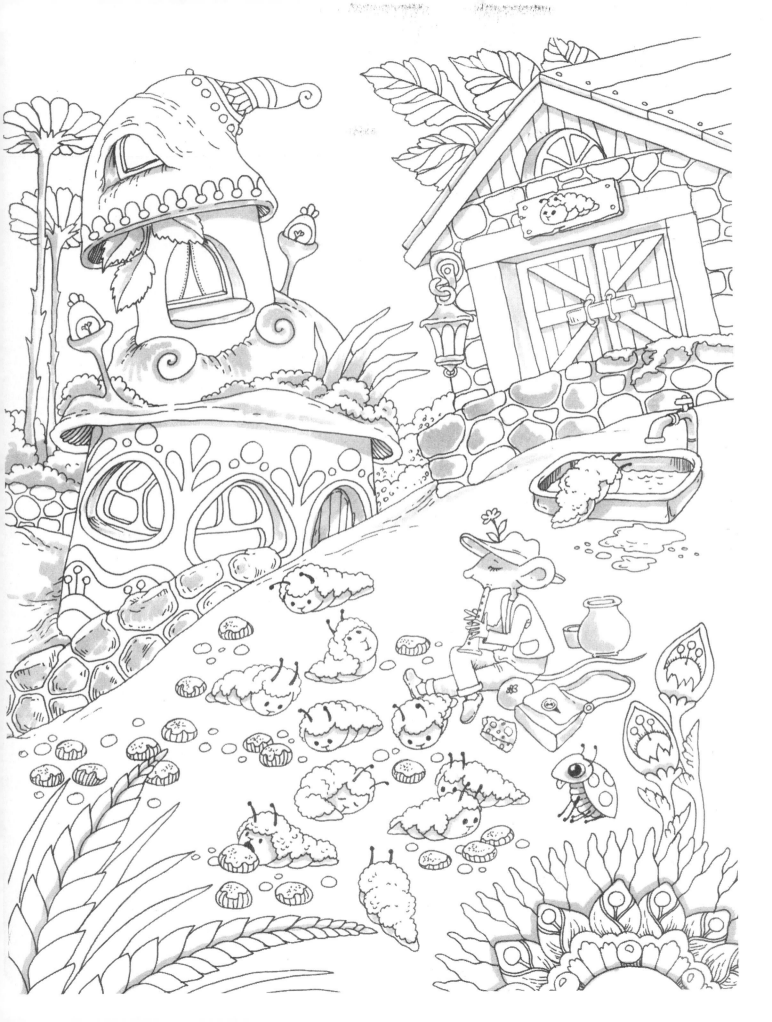

ILLUSTRATIONS
FROM
OTHER
MY
BOOKS

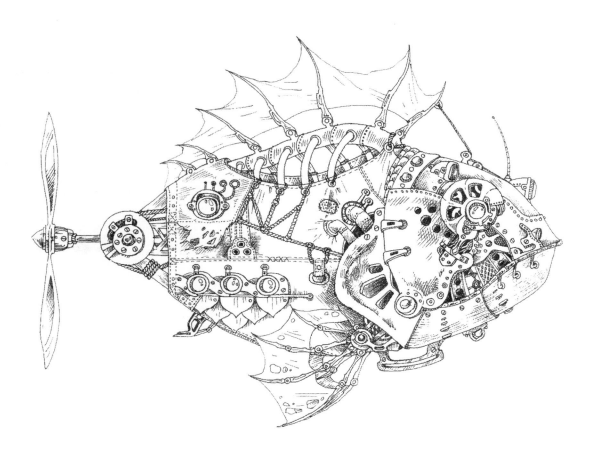

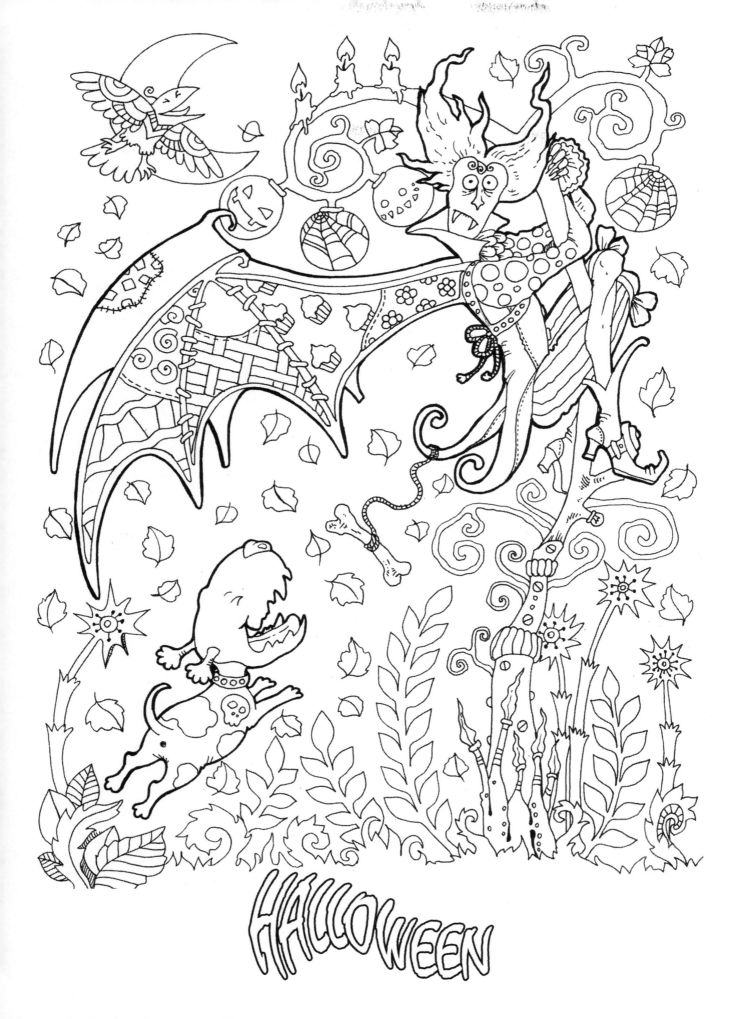

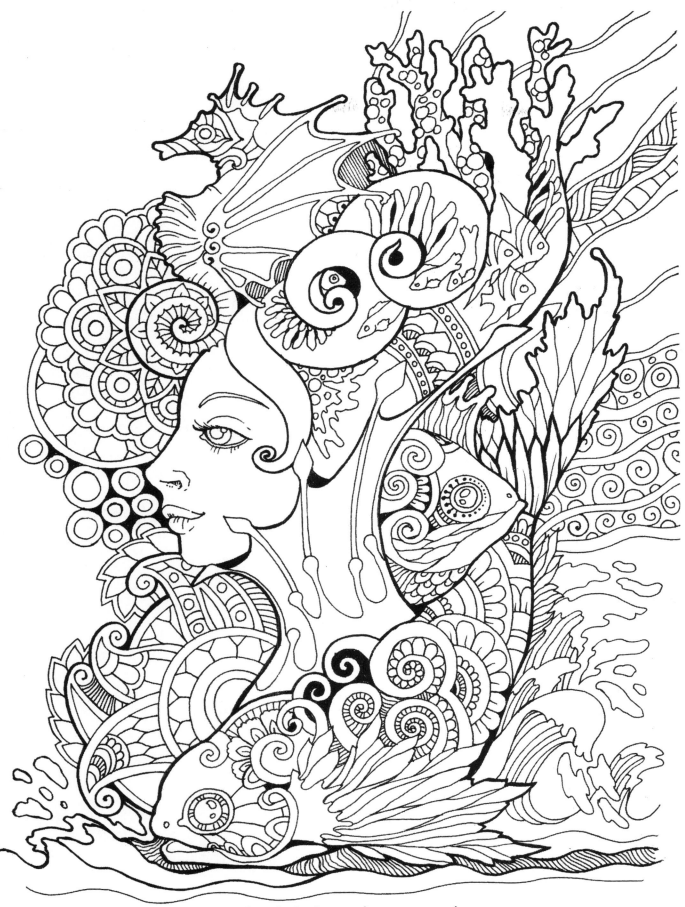

CUTE GIRLS

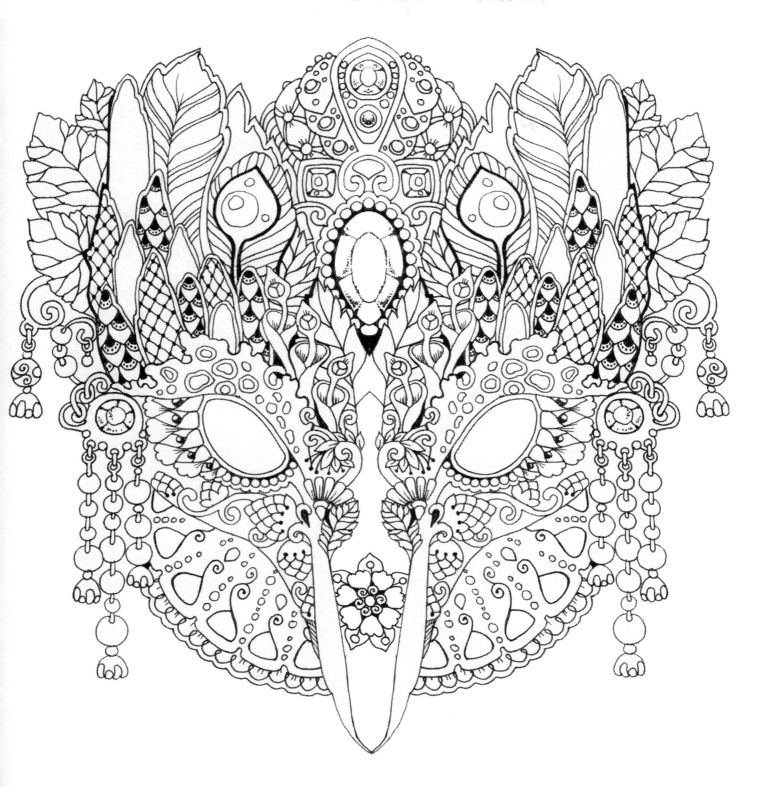

MAGIC
MASK

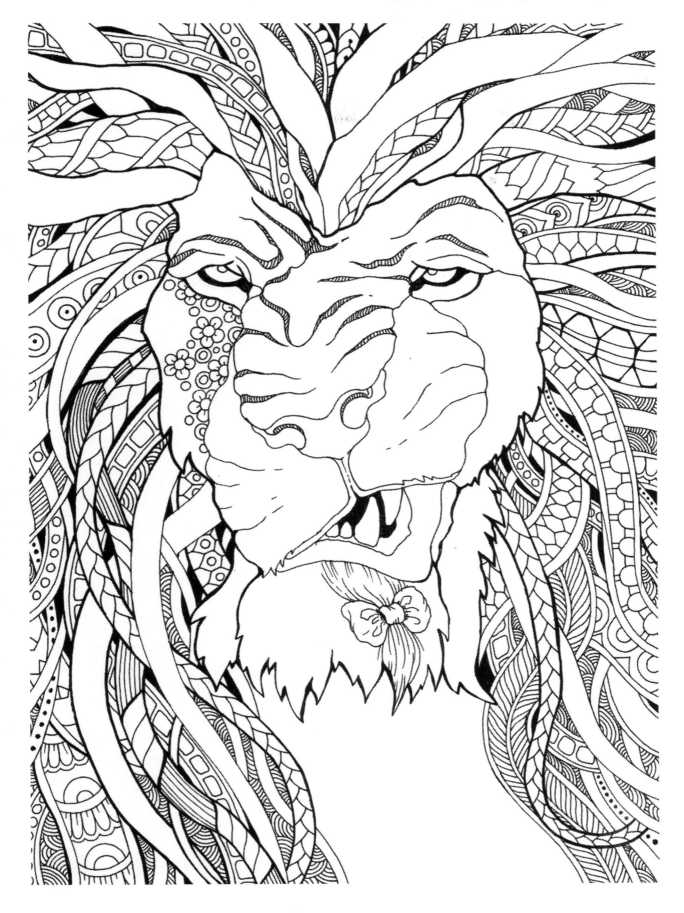

GREAT
LIONS

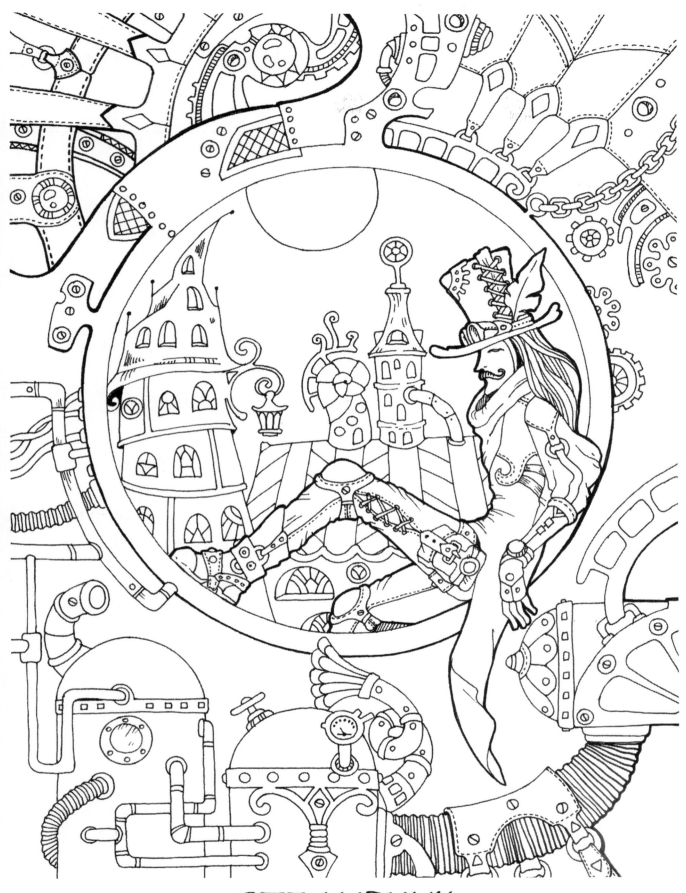

STEAMPUNK
VOL 2

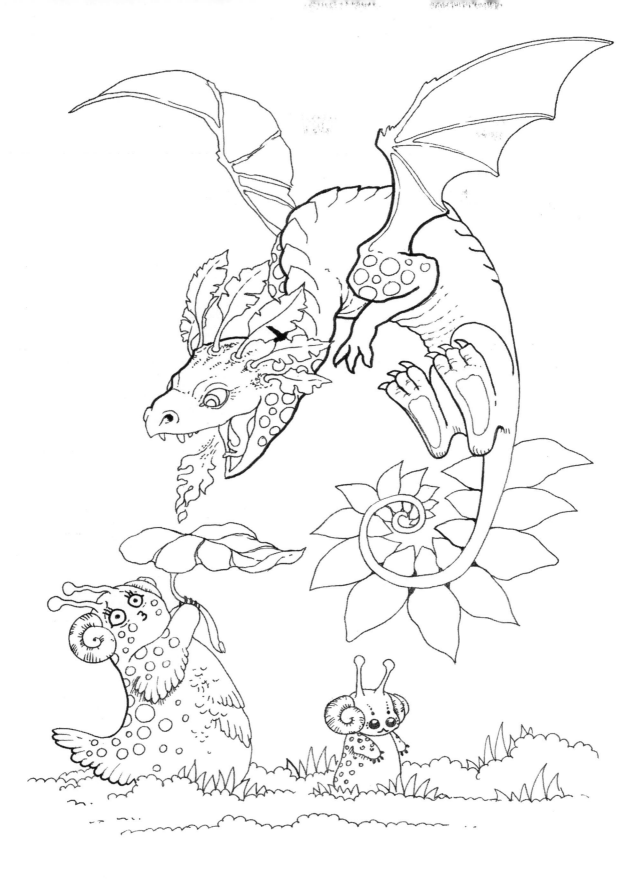

NICE LITTLE
DRAGONS

29809132R00041

Printed in Great
Britain
by Amazon